Tega

There is

Joshua
Pantalleresco

2015

FIRST PRINT EDITION

The Watcher © 2013 Joshua Pantalleresco

Illustrations © 2013 Florence Chan

Edited by Kristen Denbow

All Rights Reserved. Published June 2014

Mirror World Publishing
Windsor, Ontario
www.mirrorworldpublishing.com
info@mirrorworldpublishing.com
Mirror World Publishing publications data available upon request

ISBN: 978-0-9920490-2-7

The Watcher

Written by

Joshua Pantalleresco

Illustrated by

Florence Chan

Edited by

Kristen Denbow

No work is done alone

I thank the following people for being awesome and helpful in making this book possible:

Florence Chan and Kristen Denbow (naturally), Lance Buan for his design advice and insight, Dylen Sproul for being my first beta reader, and Dirk Manning for his encouragement.

My dad, for being my dad, my sister, for constantly inventing new ways to say the F word and for being an amazing artist in her own right, and my grandmother for her love.

Cory McConnachie and Robert McDonald for putting up with me.

Special thanks to Murandy Damodred and Justine Alley Dowsett for giving me an opportunity I never ever expected with Mirror World Publishing.

Finally, to God and whatever Muse made me see this world and story unfold. It was a surprise to me and one I'm grateful for.

This book is dedicated

To The Mills Family

For being there

I. The Watcher

alive and aware as the light comes in
rising to the sound of the morning drum
it's plantation time
all of us work extra hard
they said we'd have bigger shares this year
if we did good
we wanted to try
I look to my mom and dad still sleeping
their hands calloused
their skins toughened
catching that last extra minute of shut eye
before *they* come

the light darkens
snouts forming silhouettes in the shadows
scaly reptilian eyes and angel wings gaze down on them

he (she/it?) knows
for just a second, there is mercy
then justice rears its ugly dragon head
and roars
time to get to work

my job is atop the watchtower
I watch the skies for weather
we cannot work in rain or hail
if I see a cloud, I clang the bell
easy peasy and important
two dragons guard me from below
wielding their sticks of flame, they look up
making sure I do what I'm told
I would've anyway
I wanted that extra bit of honey
I wanted to feel the crunch of blackberries
I would be good until harvest time

days and weeks pass
the fallow ground sprouts with crops
corn and beans can be seen for miles
I gaze into the horizon
the skyscraper gazes back
it once stood tall and proud
now it is bent and tilted
covered in trees and shrubs

unable to tell the forest from itself

I cannot help but wonder
what were we like back before the dragons came?
were we like them?
strong and proud
not caring about how hard we worked others?

many claim we were better then
more prosperous and possessive
me, I think we were the same
struggling and starving
tilling concrete instead of corn
working to eat a decent meal
had we really changed at all?

even more time passes
I stand atop the tower
thinking, thinking
I don't know when it happened
But now I see things differently
I know what's going to happen at harvest time
without counting a single crop
it is not enough
it was never enough
we would always fall short
my parents would be waiting for me at shift's end

tears in their eyes
wondering just where they went wrong
blaming themselves for nothing

I'm furious now
I imagine wrapping my hands around a dragon's neck
squeezing and squeezing
until I hear something snap
and I am satisfied
I am unafraid
death doesn't scare me
because I know the truth

next year it'd start again
the same empty promises, the same cycle repeating
we'd work and work and work
and get not a shred more than a crumb from their table
the way it has always been

it doesn't have to be this way
I have to be patient
soon my chance will come
I'll bide my time until then
waiting until their guard is down
I'd steal one of their sticks of flame
using it on their headquarters
I'd burn them to the ground

afterwards, I'd seek something

there just had to be something better out there

I just needed to be brave enough to find it.

I just needed one chance

until then, I'll wait and watch

and be ready

one day, I'll be free

II. Escape

today's the day
they aren't watching me so closely
the dragons are discussing their own mundane concerns
not paying attention to little old me

my parents tried to talk me out of it
they said life is good here
why leave this place?
you have food in your belly
a warm fire at night
and story time with the others

there is nothing wrong with these things
I can't fault them for finding happiness
but how to explain gazing into the horizon?
how to talk about the birds in the air

flying far and unfettered
seeking off into the horizon
I cannot help but look and wonder
what's out there?
I need to find out, see it with my own two eyes
all that stops me now is them

the dragons with their firesticks; their wings like angels
their countenance alien and unknown
they view us like toys and slaves
filling us with empty promises
never once coming through with them
I cannot live like this

I'm scared
I'd be lying if I said I was sure of what comes after
maybe I'd starve to death or be wounded and die
maybe I'd never see my family again
I'm terrified, but I must go on
I have to know and see for myself

I've forged my weapons
I found two stones in the plantation
I rubbed them together until they sharpened
each one forming a crude blade of obsidian
tonight, I'd find out what those bastards bled
I'd burn the whole thing down...to freedom

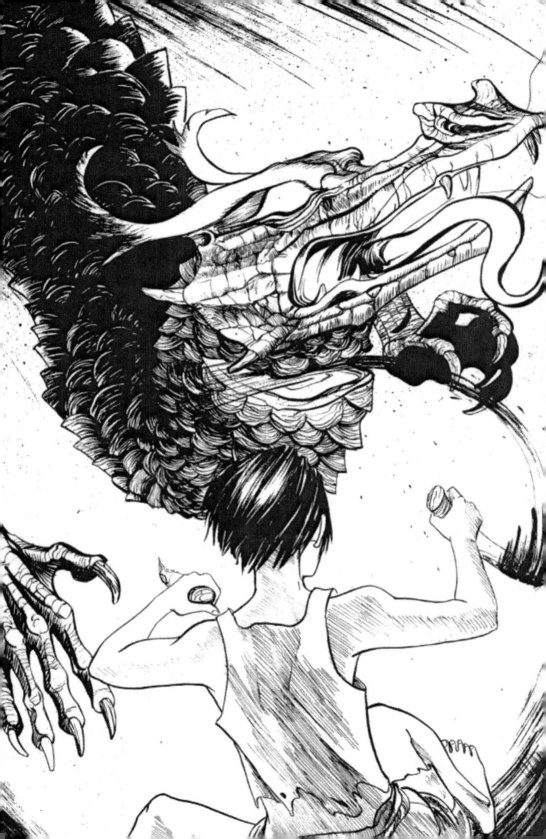

I climb to the top of the tower
I stare into the abyss of the skyscraper
instead of the same reply, I feel it beckon
did I want to see how it came about?
I could almost hear it call my name

I look down
the dragons ignore me
conversing about their own petty concerns
I realize then they are as caught up with us
as we are with them
each one feeding on the other
for just a moment I question who is the real slave here
who has the power
and just what would happen if I followed through

would they suffer for this?
would my family
my friends, all pay for my heinous crime
is it selfish if I still act anyway?
is it foolishness to even attempt this alone
if I succeed, they would deal with it, not me
is that fair?
it would be my fault, not theirs.

if I don't do this,
things would continue today like they always have

tomorrow, the same things would happen
again and again and again
an endless cycle, going nowhere
do I want to be part of it?

even if I didn't follow through today
someone would attempt to flee tomorrow
like me, they would have to know
need to see what is out there
my blades flash in the night
my decision made, I strike

both are slow to react
lethargic to my battle cry
only with a blade in one of their throats
does the other realize
something is wrong with me
I grin like the demons in folklore and I strike
I can't let him shriek out to the others
I have to end this quickly
before...

he shrieks and I panic
shit! shit! shit! shit! shit!
I can't stop now! I have come too far!
I slash and it moves impossibly fast
its claws extend and it counter-attacks

moving me back

its fear palpable and tangible

I look at its comrade, bleeding emerald

the blood dissolving the ground like acid

I grin

so this is how the bastards bleed

I go faster

claw meeting blade

its shrieks now of agony and terror

it is just a matter of time before I strike home

the others stop working

and the dragons panic

half of them attempt to hold the others back

my mother and father try to push forward

I see them mouth the question of why

all of this is in the back of my mind

as my primary focus is on my obstacle

I notice its knuckles are bleeding

my blade has tasted its blood

now it mingles and burns in emerald

it lunges for me

face and claws and sharp teeth seeking to devour

a predator attempting to seduce its prey

I shove my green and black tooth into its mouth

and twist

barely getting my hand out in time

before it closes its eyes and mouth in death

I hear the sound of shrieks

they are coming for me

I have to hurry

Flee, run and hide

in their panic to hold the rest of us at bay

the door is wide open

I don't hesitate

I will leave now and never come back

I run, grabbing one of their weapons off the ground

all my plans are forgotten as I let my panic give way

get me

out

of

here…

made it!

I head to the trees

hearing them shriek behind me

but I'm getting faster

and farther

away

so tired, but I made it

what would happen now?

III. First Night

I'm cold and frightened
hungry – so hungry
my stomach growls in the night
can't sleep
no matter how hard I try
there's no fire here

back home, at night, the fire would roar
my parents would talk to the masses
I'd hear them talk about the time before dragons
when the skyscrapers stood straight up
there was food and milk and honey
something called oil and electrickery
that powered the machines of ancient times

sometimes they would question

thinking about how silly it all was

the dragons, the fields, the plantations

why grow crops for someone else?

were my parents like me then?

did they dream like I dreamed when I gazed into the horizon?

I look at my knives and see the ebony on them

no, I'm not like my parents at all

they've never killed like I have

I still picture him perfectly

hours have gone by

but still... I see his face so clearly

the shock on it when my knife plunged into his flesh

his fear was present

was he afraid of what lay beyond?

I'll never know

will I always remember?

will I always hate?

I hear a howl and all is quiet

I feel footsteps on the ground; my heart races

I go deeper into the fallen skyscraper

I try not to flinch at the insects munching on me for dinner

I shiver and shut my mouth tighter

he heard me
I can feel him sniffing in the air
trying to find who shivered
I will myself to stay still
I can feel every pore of sweat beading down
I hope when it falls, it won't make a sound

I hear a growl and a lunge and a squawk in heated reply
something else would be its dinner tonight
I nearly collapse in relief
I sit down and exhale

what was I doing out here?
I look at my knives with the blackened blades
I'm a fool
I could've still been there
home and well fed

instead, I have no idea what I'll do tomorrow
and my family!
what would happen to them?
would they be punished for my rebellion?
maybe my parents were cowards
or smarter than I ever realized

nothing to do now, but look up at the stars

I hate it here

I want to go home

I can't though, can I?

not after what I've done...

no going back now

I look at the stars

and for a second, my problems go away

I had no idea there were so many

are there people like me

looking at the stars and wondering just what is out there?

will I find other people or will I be alone?

lost in my thoughts, I close my eyes

there is no guilt

or sadness

not even regret

just slumber

IV. The Next Day

I wake up, cold and aching
still hearing the rumbles in my stomach
thoughts of morning gruel and breakfast before the fields...
strange, the things you can find yourself enjoying
I curse memory's betrayal and look out
at the speck of light at the end of the tunnel

hesitant, I approach
last night, a predator was there growling
is he still out there?
the world is noisy
I hear birds flapping and some indistinct sounds
life is out there
in the light

I step outside the skyscraper, into daylight

midday and gorgeous

air, metal and sulfur greet my nostrils

my eyes open wide in wonder

it's overwhelming

I hear birds cawing and flapping in the distance

I hear the screech of a lizard in the sky chasing its meal for the day

I see a rabbit and a little green ooze tug of war for a carrot

all the while a cat-like lizard sneaks in behind them, watching

I step slowly, hesitant

is this all a dream, a fancy?

if I push too hard, will this shatter like glass?

will I be back home among the fields and tower?

freedom will take getting used to...

I watch the dragon-cat move to pounce

the ooze and rabbit cease their petty squabbles

staring into the hunter's eyes with terror

waiting for it to move

the tail wags and the cat obliges

pouncing headlong into...

...it appears from nowhere

a larger ooze, ten feet tall, lunges at the feline

enveloping the panicking predator in its clutches

in fear the predator-turned-prey struggles against the slime

finding his strength slowing, sapped away

paralyzing until all

...is still

what am I doing here?

how can I possibly survive in this

I don't belong

I am just a boy in a tower

not an animal in the wilderness

what options do I have in a place like this?

No.

No.

Stop. Think.

Breathe.

I can't think like a slave anymore

I am here

nothing is going to change that

and since I am here, in the unknown

I'll try to survive

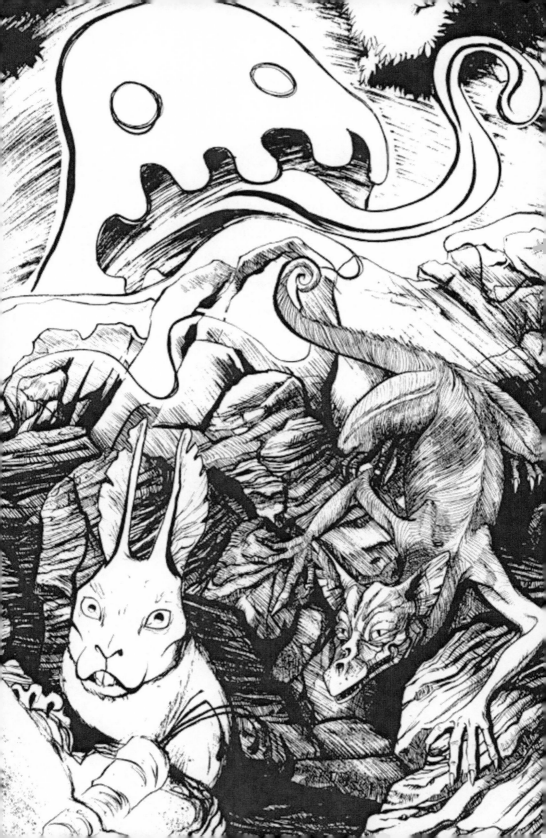

drowning inside it seeking escape

this place, hard, lush and wild, is still a blank slate

no dragons live here

no other people for miles; it's mine

mine... freedom...

it resonates inside me

since I was born, nothing has ever been mine

not even me

I was nothing to them

just a tool to be used and thrown away once I couldn't work anymore

that was the sum total of my life

until this moment

now I wasn't owned

I was a blank slate

this could be my future

if I worked at it

I could survive

maybe even more

mine, such a powerful word

but an even better one comes to me

Home.

I smile at that idea

here is something for me

it is mine to shape and mold

who knows what it could become?

for now, I need to find water
if there is life like this, it's out there somewhere
how else to explain this thriving environment?
I just need to find the source...
and then I can begin

V. Grounded Chariot

I walk for miles with caution
there are unwritten rules to this place
I have no Pharaoh to explain the penalties if I fail
death would await me, plain and simple

my parents always told stories about the Wandering God
He made the suns and heavens
men and dragons too
one day He decided to head off to the stars
making more men and dragons and eagles and chariots

I wonder if this was what He had in mind
when He made this world
was He real?
Did He listen to my pleas?
Or has he found new loves and worlds out there

forgetting all about me?

the plains are green and lush

the plants and insects in harmony with each other

black and gold bugs, fat and happy

crawling up and down those flowers, content as life can be

I see a spider wrapping one of them in its web

I can imagine the spider smiling

dinner time!

my stomach protests at the thought

I'd have to eat soon

I dismiss it

I need to find the source of water

I'm still getting used to the diversity of life

these fields are uncultivated, wild

the plants look stronger

superior

to the ones that we grew and fed ourselves

it could be the soil

nearly as black as the blades I now carry

I see the fields diversify and a trickle of water

a clear blue road surrounded by green

I see little golden fish swimming in it

amazing, that even in the tiniest specks of water life flourishes

I follow the trickle and gaze down into the horizon

the green fields are lusher and taller here

I arm my blades carefully, just in case, before stepping in them

I smell zucchini and mint

I see rosemary in the ground around me

I watch a snake slither right on by and mice scurry

this feels like home

I grab a zucchini and take a bite

I feel better immediately

the pangs of hunger subside

and my vision clears

should I grab more?

night will come again soon

I should prepare

I grab a few more zucchini and scurry on

wondering where I'm going to sleep tonight

I leave the rest of the field behind unscathed

I open to a less green

grayish wasteland

patches of earth long dead

I wonder what killed it

I see a chariot on the ground

round and oval and flawless

it still gleams metallically

not a trace of rust on it
an impulse to touch it comes upon me

I walk toward it, carefully
it could be like one of the fences in the fields
one touch and you're down
no slavers were watching me now,
what was the worst that could happen?

I gingerly approach
hoping not to be blasted into heaven
and reach out and touch it

it feels almost alive
not metallic at all
I see signs and glyphs appear on the ship
they look almost like numbers
hello ship, I say, fearful it might respond
I feel a tingly sensation
hear the whisper of a tiny voice
and then nothing

the ship dies, feeling just like metal
I explore its skin
hoping to make the numbers glow again

did it crash here long ago?

did it belong to the Wandering God?

I press on, following the little stream
munching on my zucchini, as it expands
I wonder how the water flowed in this dead earth
when everything else was extinct

I press on past the chariot
the stream grows wider
I can no longer walk across it
I see some deer and horses drinking side by side at the stream
each looking down occasionally
I wonder what spooks them in the water

I keep walking
the river picks up pace...
how long does this go?
the sun is setting
tomorrow is another day
I need to seek shelter
so I can see where the river ends

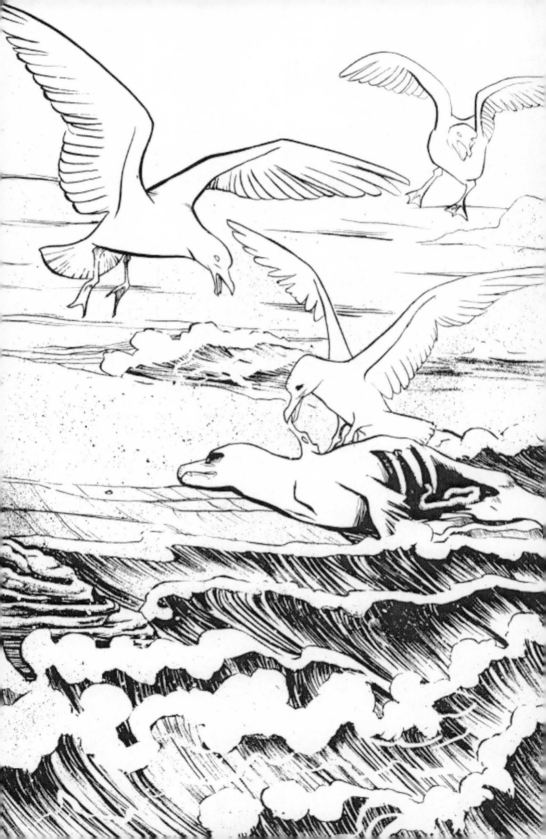

VI. Where the River Ends

the river grows
the greenery metamorphoses
soon I pass the point where I know anything about the plants

the world has changed since the dragons came
nature had been allowed to roam free
Eden was filled with thorns and walls
this time the trees have pricks and needles
why do I think they only came because of us?

for every wonder of nature I see
I see destruction
I see semblances of homes and towers leveled
some of the lights are still on
flickering
I see the horseless carriages still and rusted

once upon a time this all stood up and people used it

now it's nothing but a meal for nature

shrubs and plants break through the concrete

man-made and the wild are fighting

man-made is losing...slowly

they say it was a war to end all wars

someone out there decided to end it all with one bomb

or maybe the ocean devoured the land

one giant wave of death

swallowing the Atom Smashers

making the lakes and seas radioactive

spreading sickness across the world

I go past the lost cities

at the end, there is sand, smooth as glass

untouched by the footsteps of man

the water spreads out and the land narrows

until I come to the edge, surrounded by water

there are seagulls by the beach

flying and picking at the corpses of dead seals

even now, after all these years

you can see the mutations and sores

the damage is still being done

yet life carries on

things still try to live and breathe
they struggle and toil at life like I did the fields
is nature nothing more than simply pain?

I sit at the shoreline for a long time
me and the silence
where the river ends
I wonder what's across the water
is there another land like this?
another me sitting and staring at the ocean?
could I find a way to cross it?
what would be on the other side?

so many questions and choices
I'm hungry again
tired of berries and ants
it'd be nice to eat some birds or fish
or the deer

I can't help but drool at that
the idea of meat for the moment has me tantalized
I sit there, stomach growling
before coming out of my reverie

I look at my knives stained in black
and know – these are not the tools to catch my dinner with
these weapons are to kill, not eat with

I'd need to make something else

what to use...?

my dad always told me you needed stones to sharpen stones

like to make like

I look and clang stones together

until I find two that don't crumble under the pressure

I pick the one that feels comfortable in my hand

and start to shape it into a blade

removing it from the clay

tonight would be the last night I'd settle for bugs

tomorrow, I'd have dinner and it would be good

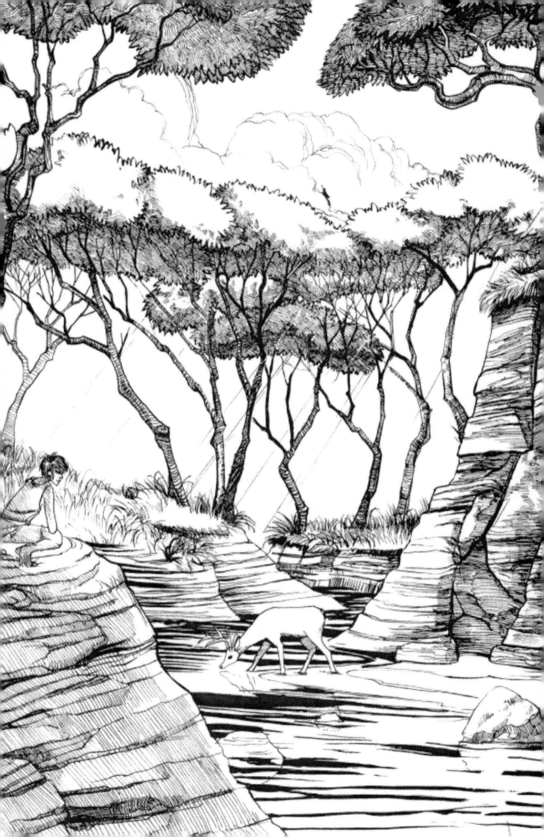

VII. The Hunt

patience was the key to those early days
the times were tough
I had no idea what to look for
the forest where the river ends cloaked all things
sights, smells and sounds were all a blur
each of them a new language I had to discover
no mom and dad to guide me
I had to sink or swim

my home grew
a piece of metal became my roof
the sand was my blanket
the rocks my pillow
it wasn't much, but it was mine
that word felt so good
I slept peacefully

not freezing anymore

my stomach rumbles
I catch his scent
he's close

I've tried killing him every day since I came here
each time he sees me coming from a mile away
darting off faster than a dragon's fire-lance bolt
leaving me to munch on berries as a consolation
tasting bitter defeat in each crunch

today will be different
I've visualized this moment perfectly
me sitting at a fire
cooking the tender meat of my adversary
savoring the taste of it in my mouth
I just had to be more patient

I knew he'd come again today
he always had a drink
this time my homemade blade would sink into him
I would not eat another berry in protest

tall antlers emerge from the forest
the rest of him follows
proud and strong

trotting with confidence and vigor
sensing me in the air as he walks toward the water

I keep myself and the hunger at bay

telling myself over and over again to wait

not yet, I mutter to myself

soon

patience

focus

the buck slows
looking cautiously around him
sensing his predator, yet unsure where he is
he sniffs and carefully dips down and has a drink

it would be so easy to charge right here
I had tried in the past and this was where I had failed
today, I wanted him satiated
slower
lazier
satisfied

when he finishes his drink he stands up
finding me waiting behind him
savoring the moment
finally

he would be mine
I grin and prepare to strike

he seems to bow at me in deference
before starting to gallop towards me
horns down and ready to strike
shit

I don't want to be hit
it would be easier to dodge

but if I did, he'd get away...again
I'd still be hungry and berries would be my dinner
I clench my homemade knife
and meet him head on

he launches me into the air, knocking the wind out of me
I gasp for air as his head collides with my ribs
it takes all my strength not to drop and roll out of the way
but I manage to stay on my feet
I grin, barely keeping it together
my turn now

I dash towards him
my blade nicks his throat and my enemy flinches
I jump at his moment of weakness
tackling my surprised prey right to the ground

I stab

and stab and stab

again and again and again

until the animal stops writhing beneath me

gasping, I roll over, catching my breath

groaning at the ache in my ribs

for just a moment I relax and rest

savoring the moment

I did it!

tonight, I will have meat!

no more berries for me!

I smile at that and savor my victory

today was a good day

VIII. Decisions

fresh cooked deer meat
coconut water for refreshment
life doesn't get any better than this

I sit and watch the sunset
well fed and content
reflecting on the past few days

so much has happened
I went from being the Watcher
transforming to a dragon-killer
now, I'm becoming a hunter
wandering
wondering, what should I do next?

I could live here

dealing with my adversaries, the deer
savoring moments like these when I'm successful
cursing the berries in the forest when I fail
staring all my evenings into the horizon
watching the waves until I'm lulled to sleep

would that be so bad?
we always worked from sunrise to sunset
never taking a moment to enjoy the simple things out there
so busy with the harvests and the work
we never saw how the reds and yellows clash
streaking the oranges into the horizon
how the stars wink into existence
opening their eyes to the world
beautiful
what more does one need to say?

atop the tower I took this for granted
how many miracles are out there, so easily dismissed?
the world is a different place
I am different

somewhere along the this journey, the slave boy died
leaving me in his place
I am no longer a tool to be used
but a free man

I only wish mama and papa could see me now
instead of the fields they toiled in

I could go back
try to rescue my parents
rescue the others that were still trapped there
take them all back here where the river ends
show them this glorious dream

I could sail across the water
I had no idea what was on the other side
does this water end at another land
or would I fall over the edge of the world?
the choice is mine
I look at the water with longing
a part of me wants to know what is out there
but I don't need to know just now

I want to see my parents again
are they even alive?
the dragons may have killed them
they had probably been punished
would they hate me for their pain?
I am afraid
but there is only one way to find out

decision made, I look at the beach

sad I am going to leave this place behind
I vow to myself; one day I'll find it again
and on that day, I won't come alone
I'll bring everyone else with me
that thought pleases me

tomorrow, the journey back begins
but for this one last night
I gaze up into the stars
and discover another miracle that has always been there

IX. The Rescue

it looks different out here
when I left
it still felt like home
all I knew was there inside
it was scary, leaving it all behind

now, it just looks hollow
a castle, made of stone and concrete
dread creeps inside me
I'm scared

what if they catch me again?
I won't be the slave boy again
never again!
no matter what, that cannot happen

the thought terrifies me

for a while, all I can do is stand at the horizon

hearing my heart cry out in cowardice

in time I calm down

focus

there has to be a way

I will find it

I had found a tool in the fallen city

a lens glinting in the sunlight had enticed me to come closer

I found it made you see great distances up close and personal

useful, I carried the tool with me

I am thankful for it here

I see them standing on guard

waiting

the dragons are mobilized

there are patrols all along the walls

the monsters stand at the doorway

intimidating in nature, with their sneers and unnatural cunning

there is hostility and pleasure in their stance

I look at my blackened blades

will they be enough to cut my way through?

there are other ways into the walls

I shudder at the stench, imagining the rot

crawling up on my skin

making me regret the thousands of times I'd used the privy

I see no other way

not if I am serious about this

and I am

I want it so bad

I steel myself and look for the secret entrance

I nearly cry out when I stumble into it

my toe throbs in pain

I cover my mouth and hope not one of them heard me

cursing my weakness, I grasp the metal door and lift it

revealing a hole to the hidden realm

I gasp; the smell is worse than I imagined

I hear a slosh as I jump down

I don't want to think about what I am swimming in

my stomach lurches, but I press on

I have no choice

I walk, swim, and tread my way toward the building

I hear thunder above me

sludge rains down on my face

the marching hooves indicate drills

strange, they never did that before

was it because of me?

I find the manhole I remember seeing in the privy

hoping no one will see me

I climb up, trying my best to go quietly

slowly

I make my way to the t o p

lifting the manhole, I push it to the side

it makes a loud clang; panicking

I stop

my heart thundering

no one replies

carefully, I peak my head up to the surface

I sigh in relief; lucky

no one was around

nor did anyone come to see the source of the noise

strange

what is going on?

I open up the slide and see the privy

lucky no one is there; I stand up

getting my bearings

I walk out of the privy

catching my breath

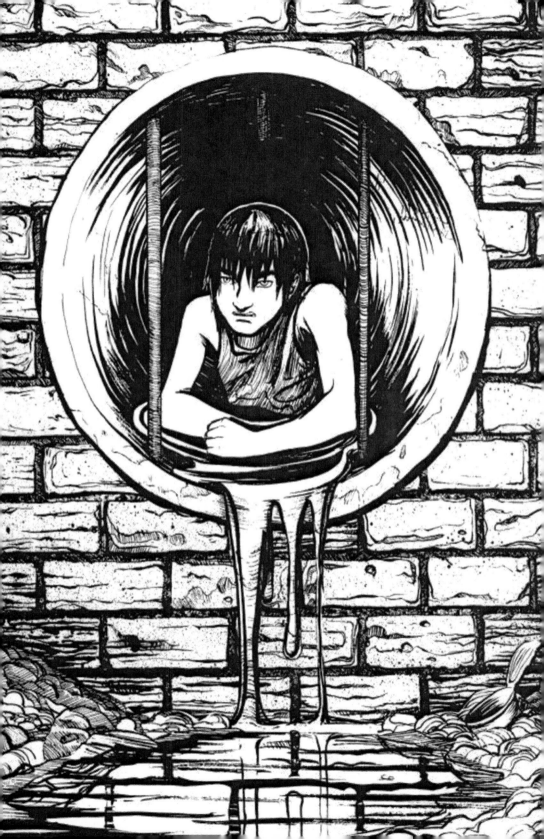

...into the shrieking sounds of children

they think they see a monster coming from the sewers to eat
them

they run and run

so much for surprises

I have to hide

and fast!

I head to the bathing areas

no longer concerned about stealth

all will converge where they saw me

and if a dragon should come...

I would worry about it then

I leap into the water

feeling the sludge and slime and stink leave me

my clothes will never be the same again

I step out of the water

mostly human

waiting for their presence

I hear them coming

I slip behind a house

watching

waiting for my opportunity

I see the beasts with the children, watching

the dragons follow them

once they see the water, they frown

growling menacingly

roaring their challenge

on the horizon, alarms start ringing

they grab the children, ushering them somewhere

I groan

taking out my blades, unsure of what comes next

what do I do now?

X. Rebellion

I follow the dragons who lead the children
frantic and frightened at what was happening
soon sounds of thunder echo all around me
panicking, I slip under a building
and watch

the dragons come
forcing the people into a phalanx
marching them to the center of the complex where the work for
the day starts
I gulp
this can't be good

I stay hidden
hoping no one has the idea to look under
wondering what to do

fight or flight?

I see friends my age first
I see Kristen, all fire and energy
she had always found ways to get me in trouble
I didn't like her
no matter what mom and dad said

I see Will
wild Will
he once wrestled a dragon-cat to save his sister
now he watches the dragons all wild-eyed
Nicki seems frightened
she is so small and fragile
I've seen my parents and others try to help her
she'd always refused
determined to do things on her own
to prove her worth

they all sit there along with the adults
the dragons surrounding them
hands itching to pull out their firesticks
I'm itching to pull out my blades

a couple of the dragons stand out, counting heads
making sure everyone they gathered is there
once finished, they shriek and the people wobble

the screams are deafening

fear is tantamount
I watch them relish it
revel in it
my vision turns red

how dare they?
my blood boils
my hesitation vanishes
it is time to fight

I slip out from under the house
I crouch and approach the nearest guard at the back
slipping my blade into his neck
my blade hisses, its colour darkening to night
he tumbles and falls without uttering a word
before his fellow guards know what happened
I strike again

the revelry turns to fear
the dragons know now what it is to be afraid
I am the Dragon Slayer
the second guard tumbles to the ground after the first
the black eclipses the blades completely now
transforming them into ebony blades of shadow
blanketing the battlefield with death

I relish the battle nearly as much as they do
there is a madness in their blood
it sings to me
beckoning me to join

I understand then
who the dragons are and why they are here
they crave violence
they are seduced by its call
they conquered us in this dance long ago

their lust for things
our weakness for toys and trinkets
our distractions in the mirror
our impoverished starving left us in the cold

they took advantage of an opportunity
subjugating us
beating us down with oppression
we had done most of the dirty work

yet for all their power, they are afraid
they need us to feed their bellies
they need us to live their quality of life
they need us to be free
they need us to be comfortable

this is why they torment us
to keep us down
to stop us from creating people like me
they fear dragon-killers

this all known
they had to destroy me
and they had to do it now
before my sickness spread to the rest
before we remember that we are people
who don't need them at all

I know what I have to do
I keep slashing
trying to cut as many down as I can
knowing the battle is in vain
the dragons have stopped being afraid
organizing and using their shields to surround me
absorbing my meager blows as if they are nothing

it is just a matter of time
I try to distance myself, but it is futile
they've surrounded me
all that is left for me is to fight
my end has come

I am at peace with it

I'm not afraid to die
I am no longer a slave
I'd never be one again
that is enough

the dragons are tripped up behind me
surprised, we all turn around
wild-eyed Will and Nicki are scooping up weapons
Kristen grabs the first firestick and fires
cooking a dragon where it stands
the adults join rank

the dragons shriek and we roar in response
we no longer care what happens next
we are no longer going to be slaves
together in common cause
we rebel
we battle for our freedom
whatever happens next, we'll have earned it

XI. In Fire

flames dance along the orchards
chittering away at the walls, devouring the fields
no harvests will come this year
the compound is coming down
what remains to be seen is if it will all be ash
too many corpses fuel the fire
human and dragon both, fighting each other for primacy
it is all my fault

I've caused this with my actions
catalyzed it, when I ran away
by becoming more than I could ever hope to be
I burned all this behind me
my own people suffering...
I kick the dead dragon corpse away from me
blood from my blades drips and plunges into the flames

they lick the precious blood and grow

begging for more

waving to and fro from the battle

there are a handful of us left

we had done well and killed many at the start

but the dragons are soldiers

shaken, they still stand their ground

until we settle down

losing our momentum

we are simple slaves

fighting to the end

but this is the end

would this have happened without me?

maybe, but probably not

if it wasn't for me

they never would have fought back

I say sorry to those that can hear me

to my utter shock, they shush me

wild-eyed Will makes me take it back with a glare

I can see he wanted this, in spite of the price

like me, he wants to be free

Nicki is still small, but no mouse

there is steel in her stare

she is proud
Kristen comes to me and shushes
she whispers the truth to me
and I understand

I may have been the match
but this inferno was coming
because they simply wanted more

they wanted to hate me when I ran away
not because I made it harder
but because it was something they understood
they were shamed because they didn't do it themselves
over time that shame became more inquisitive
where did he go? Kristen asked
what is out there? Will replied
is there really more? Nicki squeaked

as the dragons surround our dwindling band
I answer them all with a word
yes, there is more
so much more
than the mundane fields we planted in

day in and out
doing our menial labors and chores
serving our masters

we had forgotten how small we are
and how large the world really is

lost cities
grounded chariots from the sky
sunsets and dragon-cats
starlit skies and coconuts
this world is truly wondrous
it will make you large like it is, if you let it

satisfied, we smile
battered, bruised and surrounded
we stand there unbeaten
the dragons are furious
years of work and toil and rule all gone
this compound will never be the same again
I take comfort in that
as the lead dragon aims his firestick at me
there is fear
but there is also peace

it is okay to die here
I smile at death
waiting for him to pull the trigger
ready
aim

BAM!

more dragons fall from behind
sleeping now in the fire
I look up and see them
I smile
mama, papa
you're all right!

they stand with others, each of them with a firestick
they seem relieved to see us still standing there
for a moment, I think they'll come down and reunite
until I hear the whirring of blades
the thunder of ignitions

the spinning chariots can be seen on the horizon
more dragons are on the way
we have only delayed the inevitable
soon we'd be swarmed again
the fire grows frantic around us
as the compound nears its death throes

my parents point to the long abandoned doors
the flames haven't touched them somehow
if we act now, we still might get away
mom and dad point to the door...

...I know then, without a word
I'll never see them again
I want to scream
I've come so far,
only to never see them again
it isn't fair

No.
I don't have to leave
I can stay and fight to the end
we all look and nod
deciding to throw our hats into the final battle

our parents shake their heads
pointing to the door emphatically
they want us to escape
they don't care about themselves
I still might've tried
until mama offers four magic words
I can't hear them, but I see
and I am moved to tears
"I'm proud of you."
I feel myself dragged away
relieved at that permission
sad I'll never have to get it again
escaping forever from the place I was born
hearing the whirring planes go in the fire behind me...

XII. New Worlds

we made it that night
sneaking and hiding in the darkness
the dragons tried to find us, but couldn't
their screams can be heard in the distance
someday, we'd fight them again
for now though, we seek our own world
our own place of belonging

it's strange to see my friends out in the wild
like me, they are terrified of freedom
stunned by the sights and sounds that surround them
but, little by little, they accept it
Will gapes at the oozes struggling with the rabbits and squirrels
Nicki looks at the streams and views a million different fish
each so small, yet thriving
Kristen stares at the stars

wondering if they stare right back

we all grow together each day
overcoming each new struggle
laughing, learning and becoming bigger
leaving our old selves behind

I have no idea if we'll make it
the future is so uncertain
there is so much out there that we have never seen
so much we don't know
so much to discover
I doubt we'll see it all in our lifetime

there is guilt there
we've lost so many already to get this far
I think about mom and dad every day
they each talk about some little thing their parents did for them
something they'd always took for granted
only now realizing how special it was
I wonder if they watch us, even now
I'd like to think so

we walk in the wastelands
seeking our own place in the world
where no dragons dare to tread
I think about who I am

and who I have become

slave boy to dragon-killer
now I explore the new world
who knows what I'll be tomorrow

for now, with the others
I wonder just what is next
if tomorrow will be something better
for now, that is enough

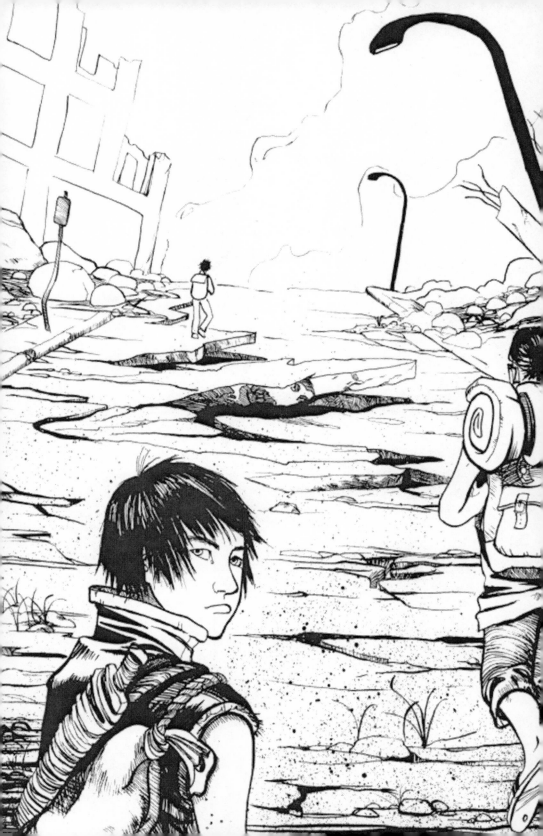

Thanks for reading!

Since we're going to print, I want to take this moment to thank a few other people. I want to thank each and every person who retweeted, favorited and did what they could to promote my book. The Watcher would have never made it this far without you.

This book has been the happiest accident I've ever written. I hope you enjoyed it. I want to take this opportunity to thank everyone involved that made this happen - including, you the reader. Leave me a message at michaelthroughtime@live.com to tell me what you think.

One last favor I have to ask: Can you please let people know this is out there? I appreciate it.

Once again, thank you.

There is more.

mirror world publishing

Joshua Pantalleresco writes fiction, poetry and comics. He also loves to do interviews. He has written columns for comicbloc and allpulp and currently does so for comicmix. He has a website filled with interviews and other random writings http://michaelthroughtime.wordpress.com. His twitter handle is @jpantalleresco. The Watcher is his second book of poetry. He resides in Calgary.

Florence Chan is an illustrator, photographer and graphic artist who creates both two and three-dimensional artwork across a variety of media, both traditional and digital. She dwells in the realm of geekery, hails from The Stampede City and currently calls Toronto home. Her webpage is http://www.florencechan.ca and her twitter handle is @florenceachan

Kristen Denbow writes and edits in her spare time. She enjoys investing her time in projects that are interesting and add to her experience as a writer, editor and artist. Poor grammar, misspelled words and misplaced punctuation are her chriptokn!ght.

CPSIA information can be obtained at www.ICGtesting.com
Printed in the USA
LVOW13s0747290614

392153LV00001B/2/P

9 780992 049027